Left Field Strikes Back!

The Third Onslaught of Cartoons

Randy Halford

authorHOUSE®

AuthorHouse™
1663 Liberty Drive
Bloomington, IN 47403
www.authorhouse.com
Phone: 1-800-839-8640

First published by AuthorHouse 12/9/2010

ISBN: 978-1-4567-1331-7 (sc)
ISBN: 978-1-4567-1338-6 (e)

Printed in the United States of America

This book is printed on acid-free paper.

Certain stock imagery © Thinkstock.

FOREWARD

STRIKES BACK, indeed. This third go-round
has allowed me to flex my creative muscles
even further. Not only have I continued to
satirize everything I can possibly think of,
I've given this book a slight edginess in its
humor. From the sophomoric ("Hi-definition/
'high' definition") to the outrageous ("Attack
of the Fifty-Foot Transvestite") to the down-
right creepy ("The Silence of the Lambs:
Valentine's Day")---to name a few---*Left Field*
is a sort of juggernaut that keeps amazing
me with its growth spurts.
Quick note: This book contains the last of
my earliest cartoons, allowing the collection
to build in both quality and hilarity. So if the
early stuff's humor seems occasionally dated
(remember the Y2K scare? Bugleboy Jeans
commercials?), then they're simply a product
of their time.
Well, I've rambled on long enough.
DIG IN!

BACKWARD

FOREWARD

STRIKES BACK, indeed. This third go-round has allowed me to flex my creative muscles even further. Not only have I continued to satirize everything I can possibly think of, I've given this book a slight edginess in its jump from the sophomoric ("Hi-definition\ hirr," attention? to the outrageous ("Attack of the weasels") to the down-right creepy ("The grinch and the Lombar Valentine's Day")---to name a few. In Field is a sort of juggernaut that keeps cramming me with its growth spurts.

Quick note: This book contains the last of my earliest cartoons, allowing the collection to build in both quality and hilarity. So if the early stuff's humor seems occasionally dated (remember the Y2K scare? Bugleboy Jeans commercials?), then they're simply a product of their time.

Well, I've rambled on long enough.
DIG in!

TAKE A BOW...

To my lovely Mom for always believing in me.

To my sister Kim for once labeling me a "late bloomer"...you were so right! Love you, Sis!

To Authorhouse for their uncanny timing in luring me back for another book.

To my friend Gregory Brucks... a sympathetic ear and first in line for my books. Here's to another Panda Express lunch!

To my friend/neighbor Lori Enrico for helping me update my author photo.

And to those who have stuck with me through three books...THANKS SO MUCH!

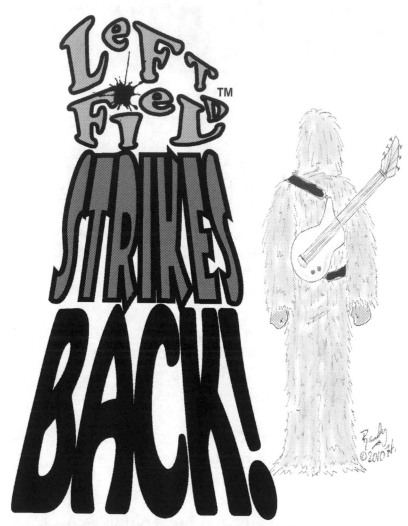

LeFt FieLd™ StRiKeS BACK!.

**THE THIRD ONSLAUGHT OF CARTOONS
BY RANDY HALFORD**

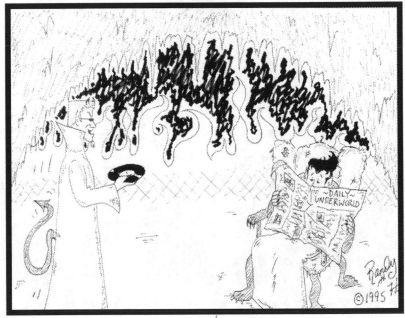

"GET A LOAD OF THIS, DAMIEN! IF YOU PLAY THIS ALBUM FORWARDS, YOU HEAR--BLECCHH!--WHOLESOME LYRICS...!"

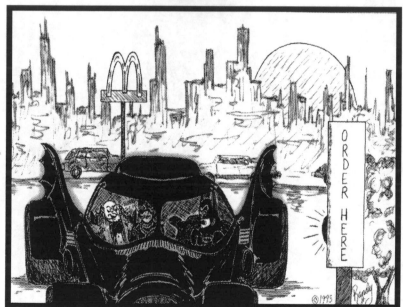

"CAN'T YOU TWO BE ORIGINAL? EVERY TIME WE COME HERE, IT'S THE SAME 'OL THING.. FILET 'O FISH! FILET 'O FISH!"

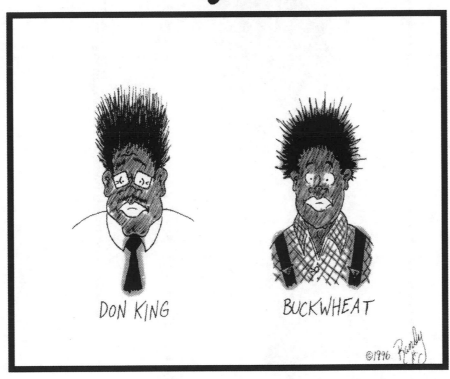

DON KING BUCKWHEAT

©1996

SEPARATED AT BIRTH

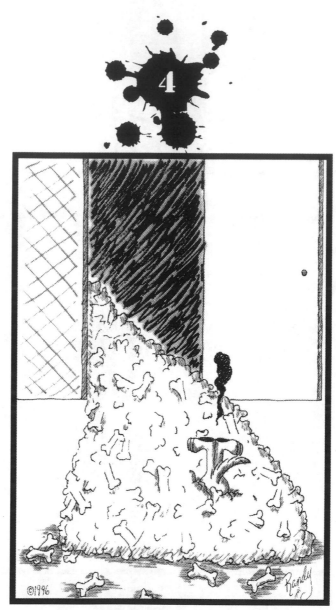

MOTHER HUBBARD RE-STOCKS HER CUPBOARD...

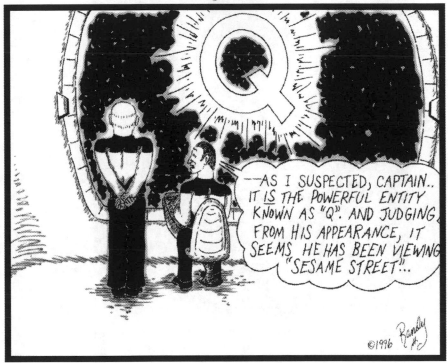

FROM "STAR TREK: THE NEXT GENERATION" (LOST EPISODE)

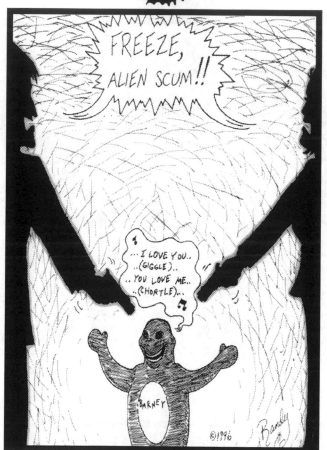

FROM "THE X-FILES"

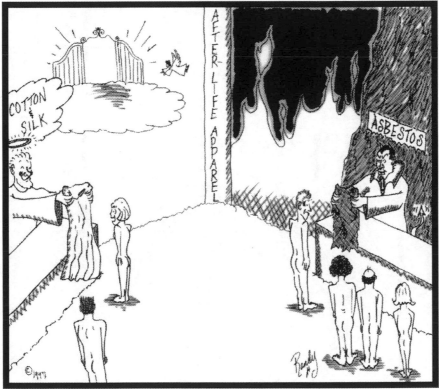

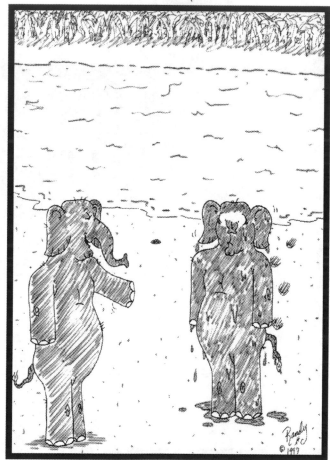

"WATER COLD?"

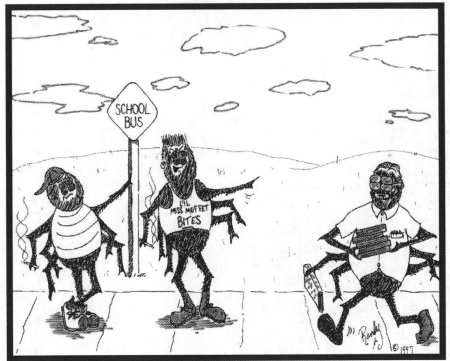

"..HEY, BUTCH! HERE COMES THAT NERD, 'OL' EIGHT EYES.."

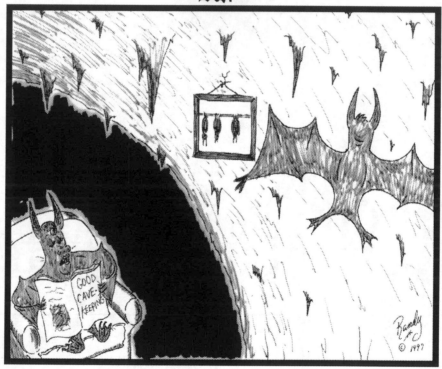

"TURN ON YOUR RADAR, DEAR"

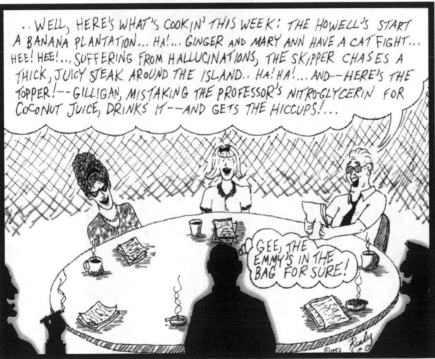

A TYPICAL WRITING SESSION FOR "GILLIGAN'S ISLAND"

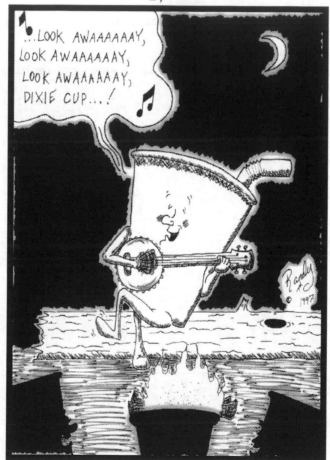

DRINKING CUP SING-A-LONGS

FLOWER MASHERS

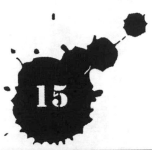

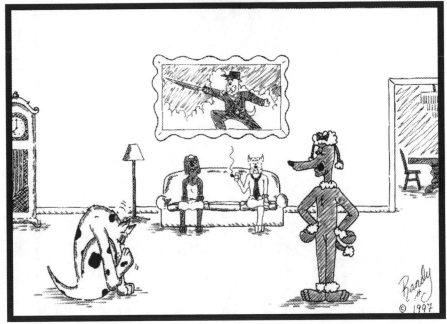

"OH RALPH––REALLY! WHEN THE BOWSERS' SAID 'MAKE YOURSELVES AT HOME', YOU DIDN'T HAVE TO TAKE THEM SO LITERALLY!"

16

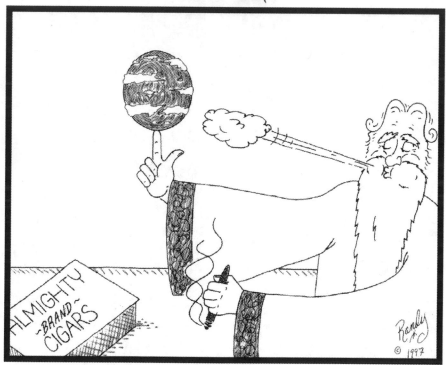

HOW GOD CREATES CLOUDS

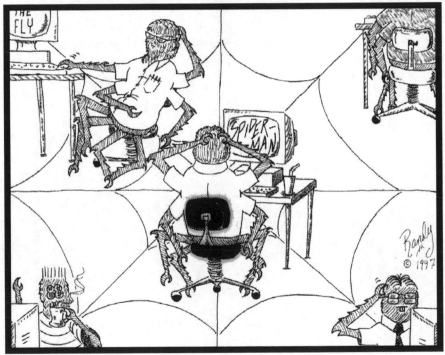

THE WEB-SITE

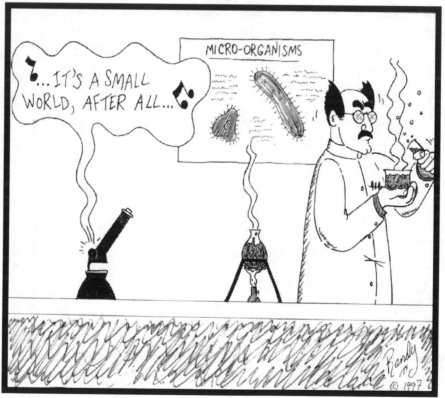

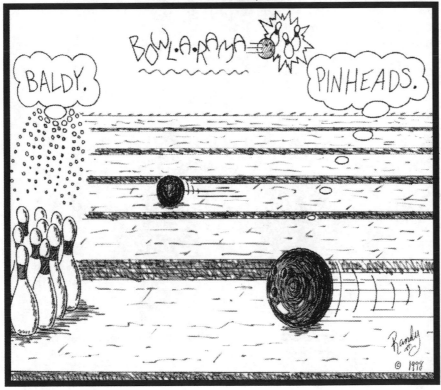

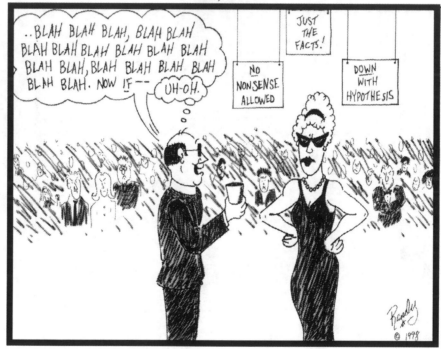

..IN THE MIDST OF THE "STARK REALITY CONVENTION", MELVIN ACCIDENTALLY UTTERS THE "IF" WORD...

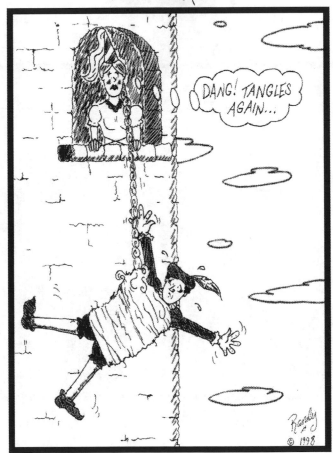

RAPUNZEL'S ROMANTIC PITFALLS

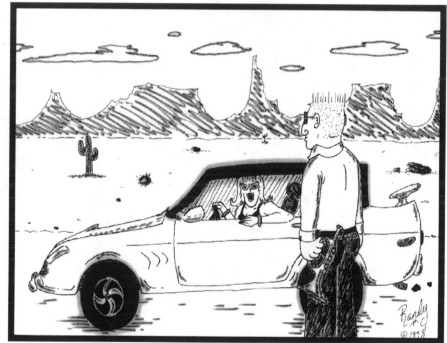

"SAY, BUGLEBOY...ARE THOSE JEANS YOU'RE WEARING?"

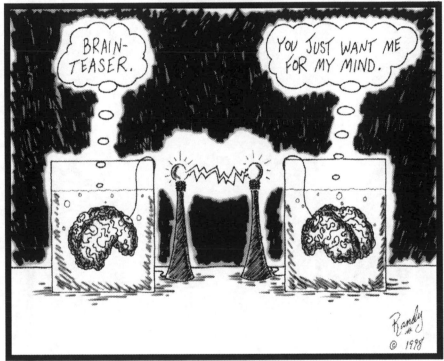

MIND GAMES

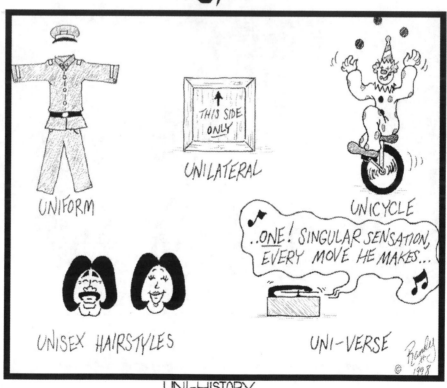

UNI-HISTORY

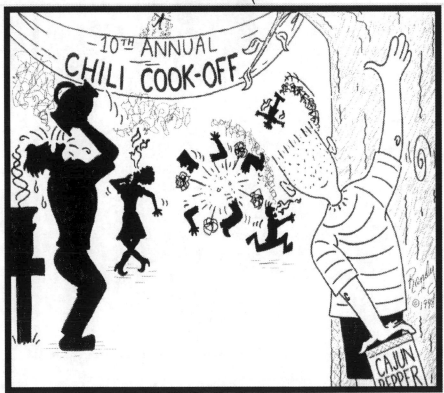

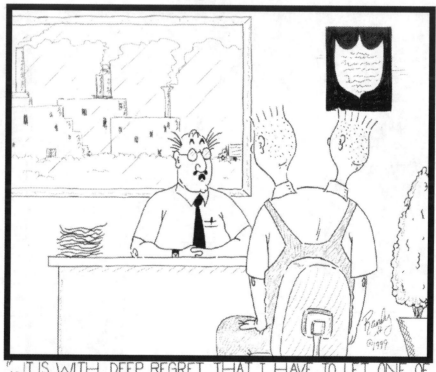

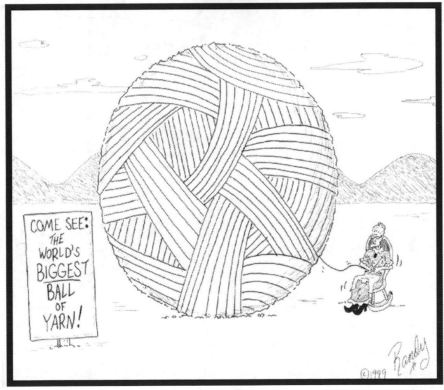

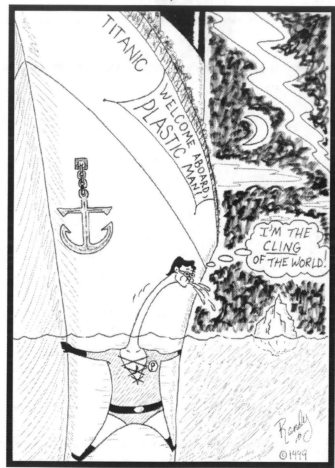

STRETCHING HISTORY

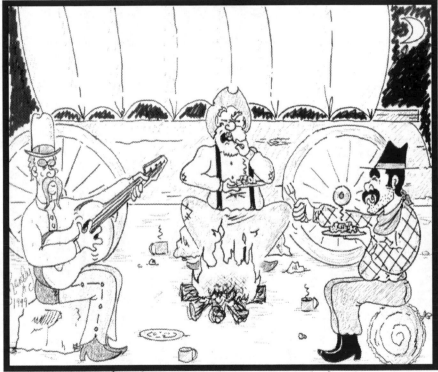

"KNOW ANY SHOWTUNES ?"

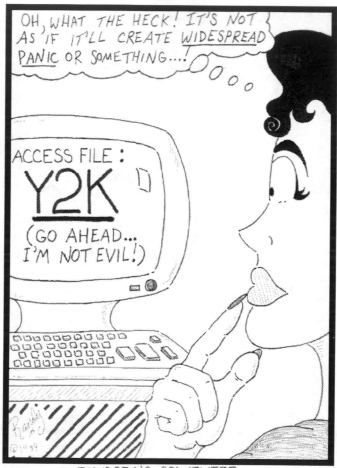

PANDORA'S COMPUTER

AT THE LIBERACE MUSEUM

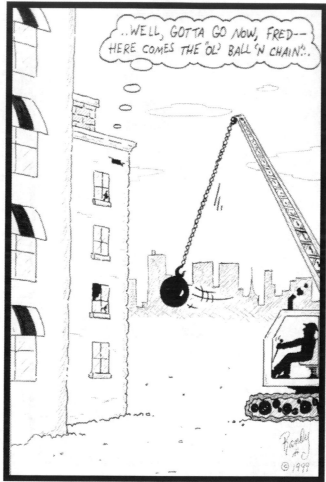

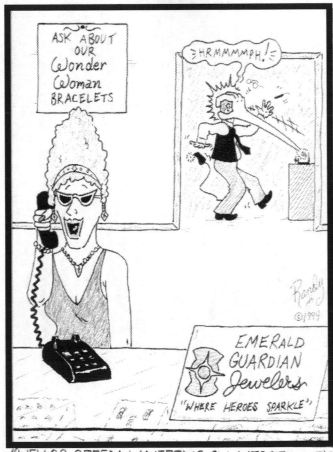

33

"HELLO? GREEN LANTERN? OH, YESSIR! HE'S CLEANING YOUR POWER RING RIGHT NOW!"

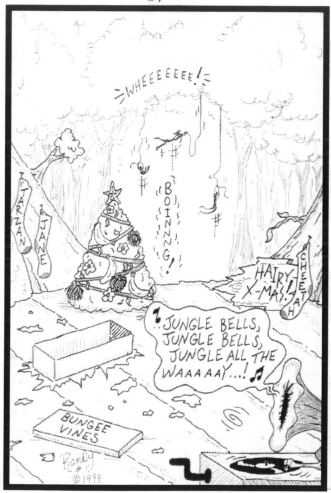

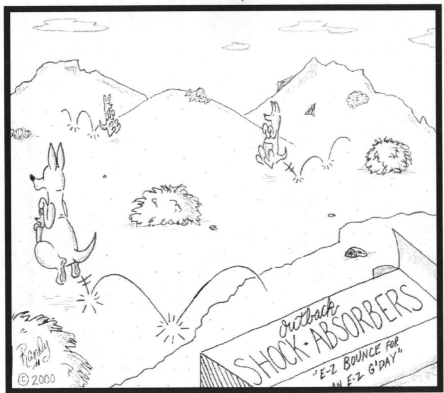

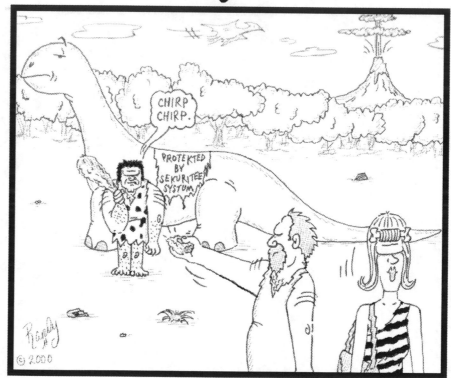

THE FIRST CAR ALARMS

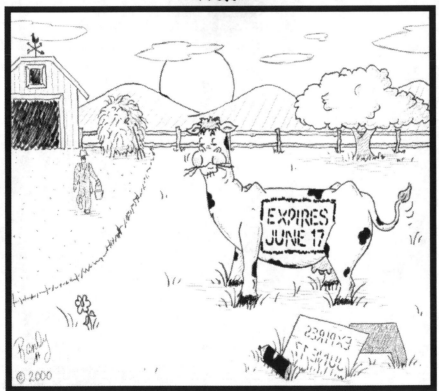

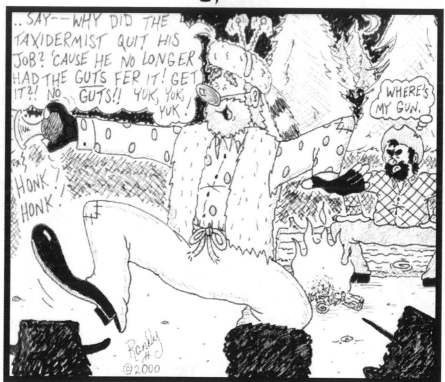

PATCH "GRIZZLY" ADAMS

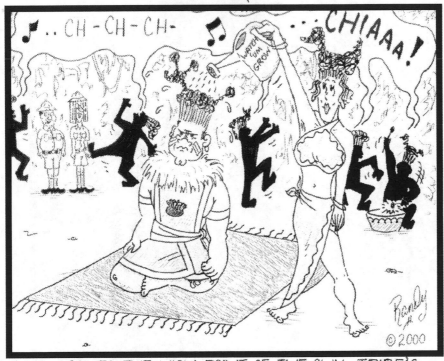

"..NOW COMES THE HIGH POINT OF THE CHIA TRIBE'S
CEREMONY: 'THE WATERING OF THE POODLE HEAD'..."

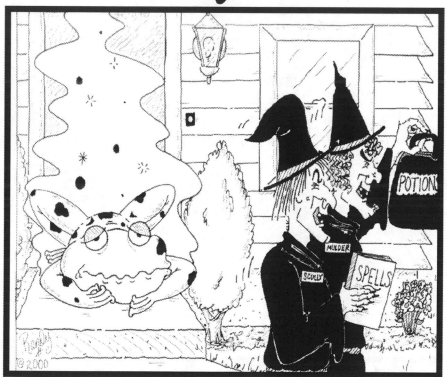

T.V.'S "THE HEX FILES"

41

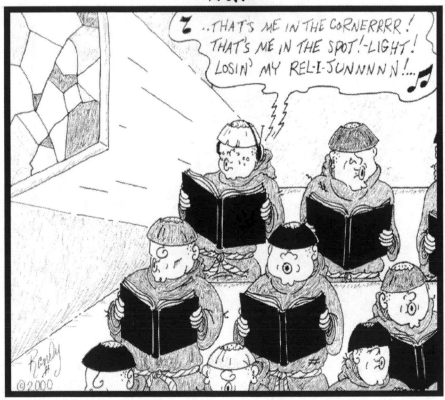

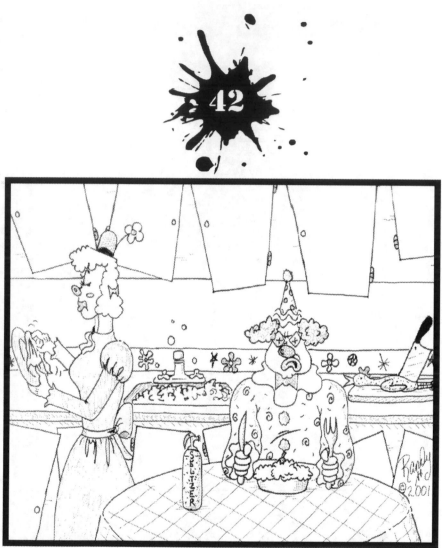

"CREAM PIE AGAIN?!"

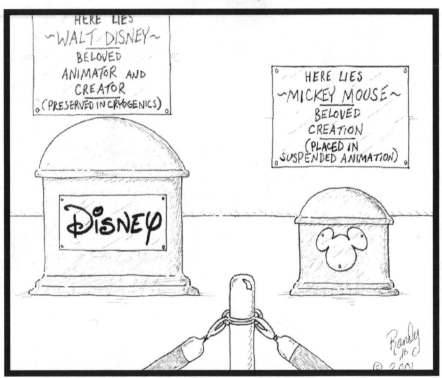

AT THE DISNEY MEMORIAL

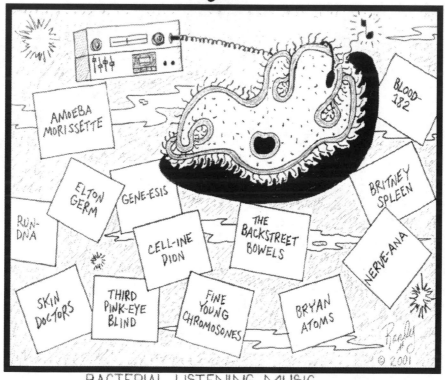

BACTERIAL LISTENING MUSIC

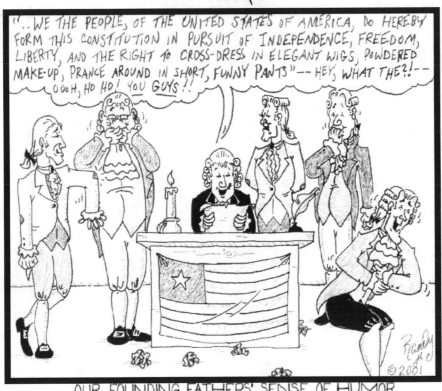

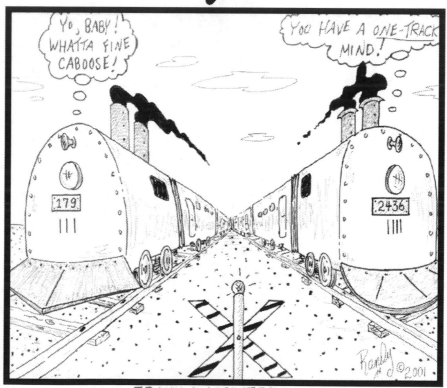

TRAIN MASHERS

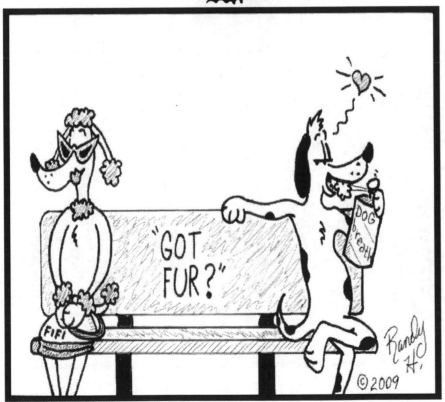

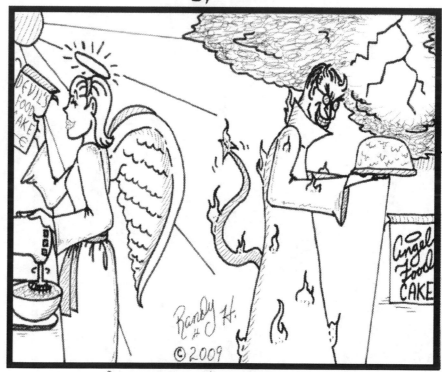

SAMPLING THE OTHER SIDE

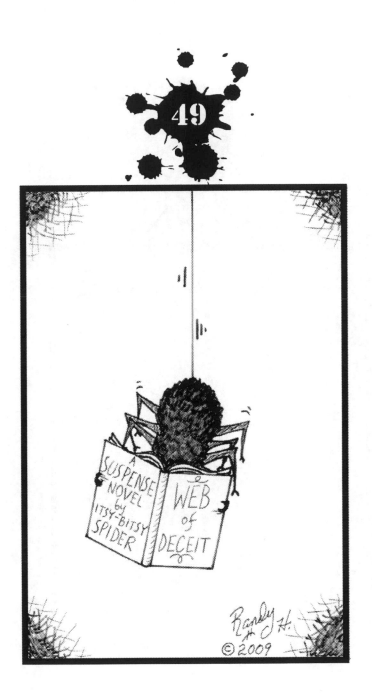

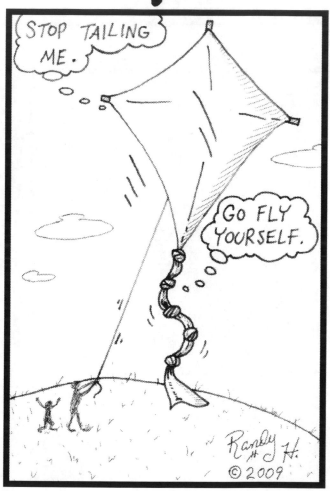

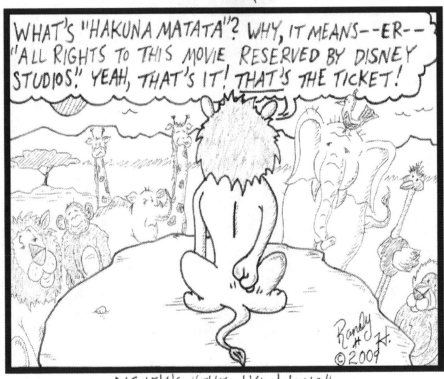

DISNEY'S "THE LYIN' KING"

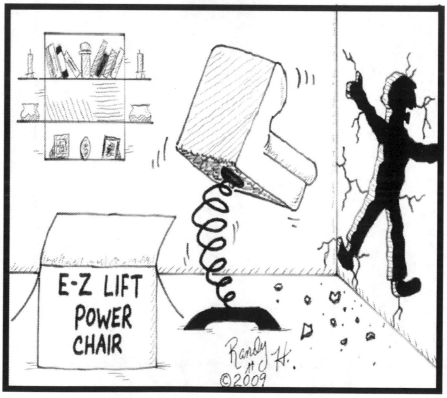

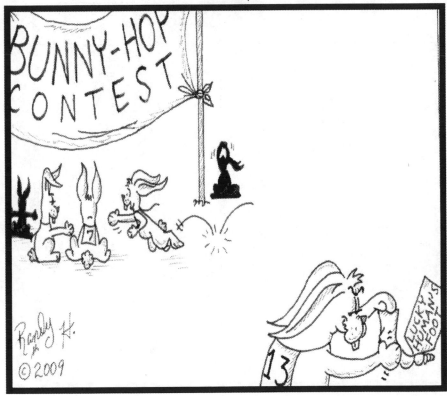

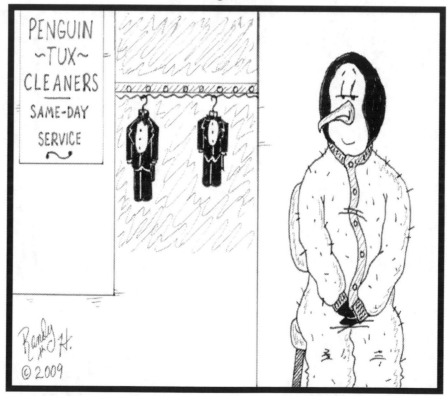

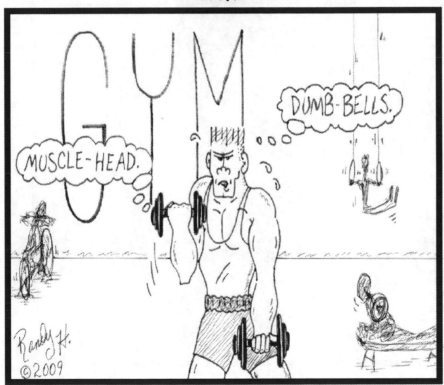

56

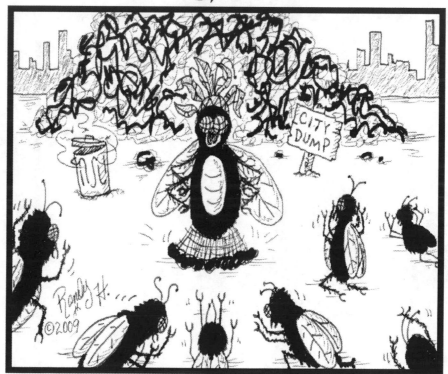

THE CLASSIC NOVEL "LORD OF THE FLY DANCE"

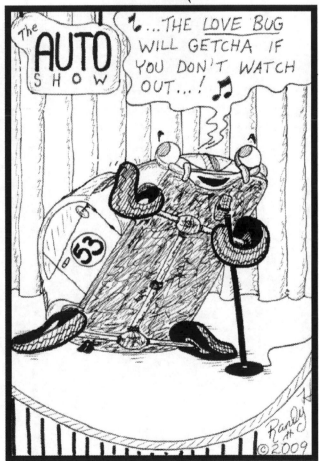

HERBIE THE CROONER

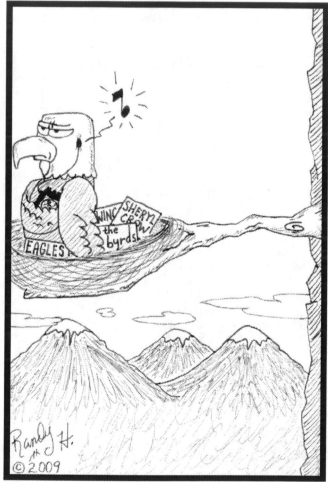

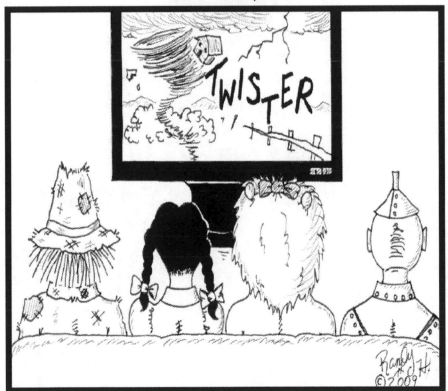

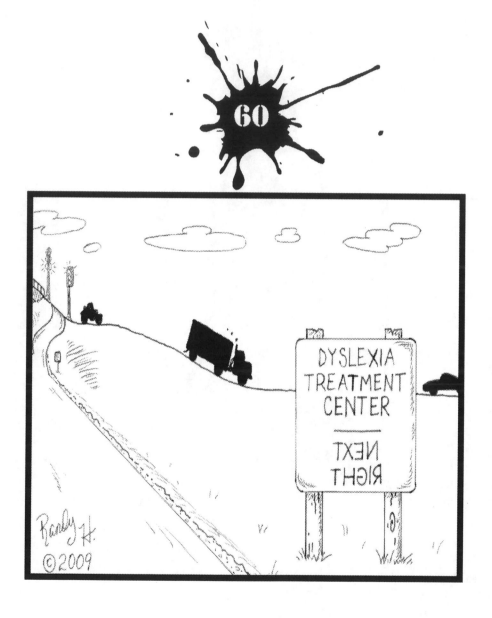

61

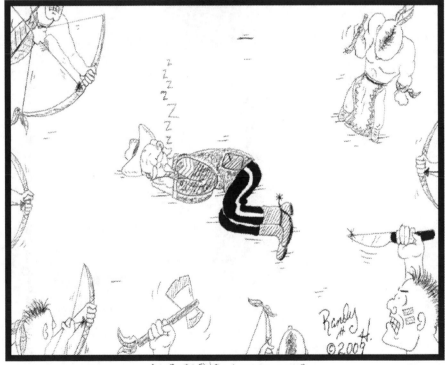

CUSTER'S LAST NAP

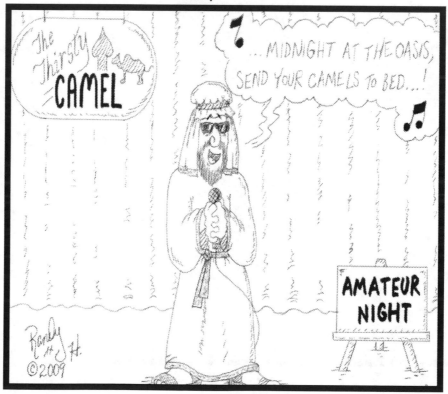

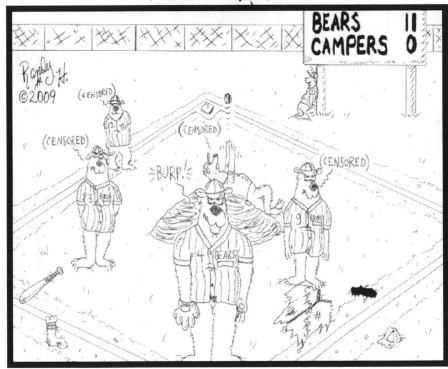

SCENE FROM "THE BAD NEWS BEARS"

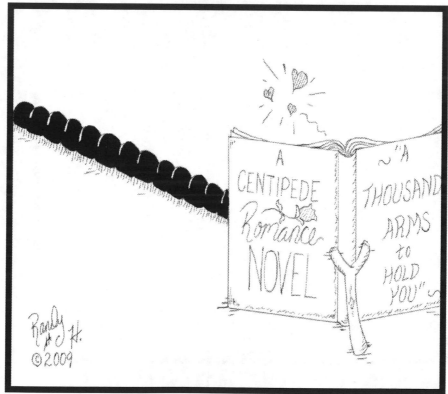

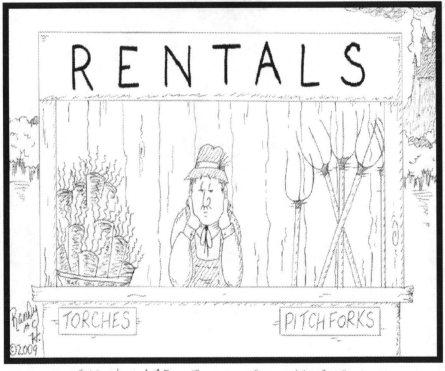

THE VILLAGE OF DR. FRANKENSTEIN

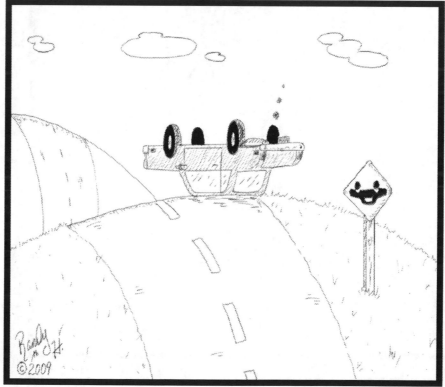

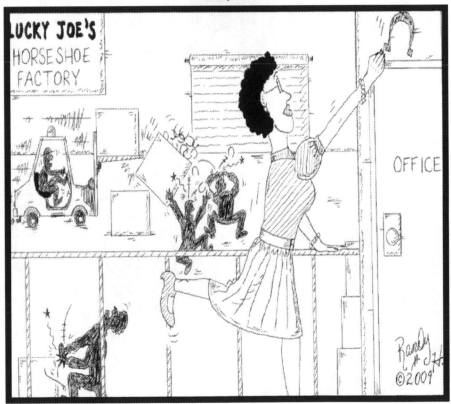

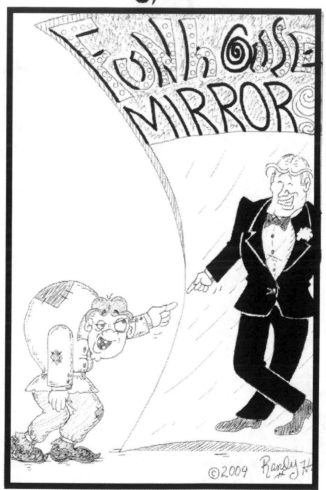

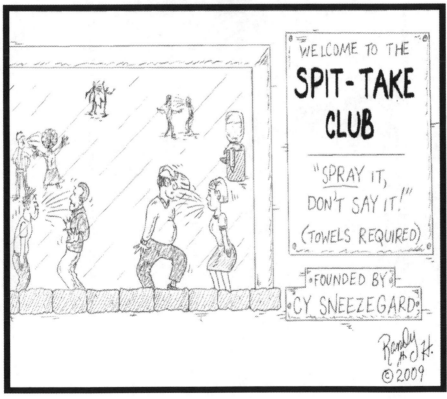

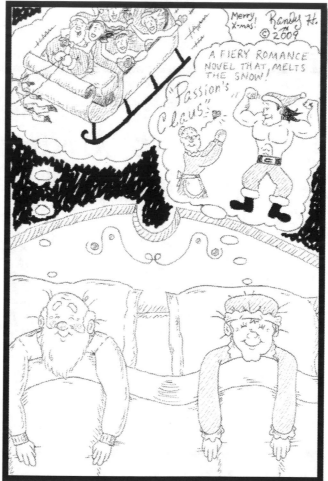

71

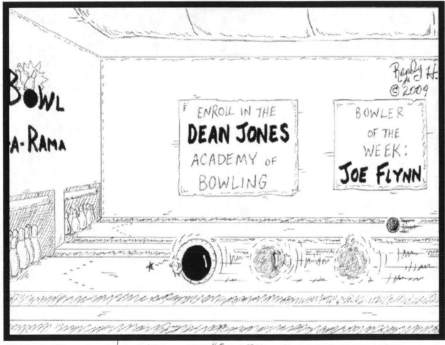

THE LIVE-ACTION DISNEY MOVIE "SCALES: THE SNAKE THAT LIKED TO BOWL"

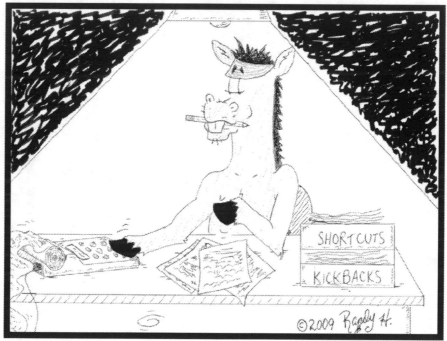

THE LIVE-ACTION DISNEY MOVIE "BUCKY: THE MULE THAT COULD DO TAXES"

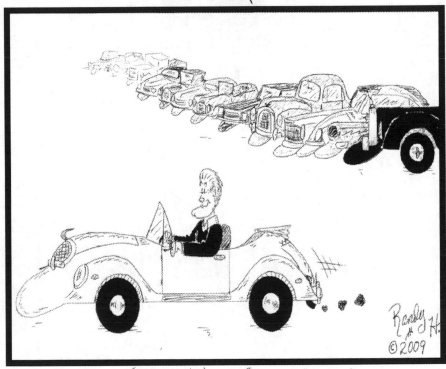

JAY LENO'S CAR COLLECTION

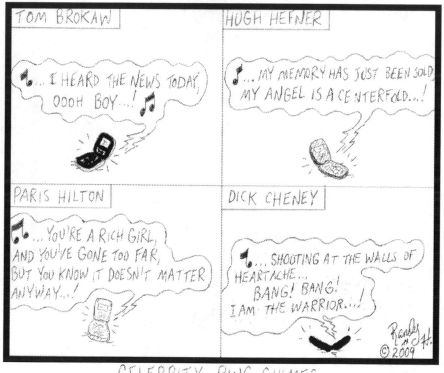

CELEBRITY RING CHIMES

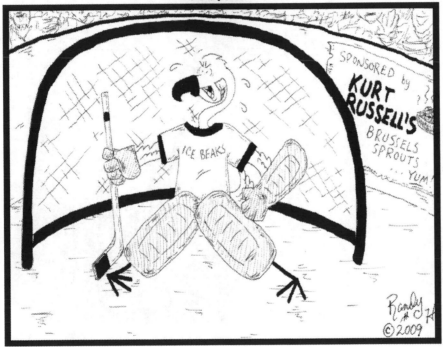

THE LIVE-ACTION DISNEY MOVIE "PINKY: FLAMINGO HOCKEY GOALIE"

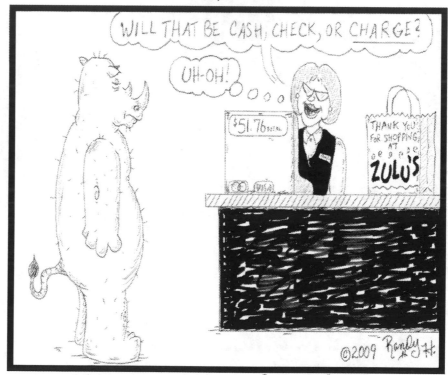

WHAT NOT TO SAY TO A RHINOCEROS

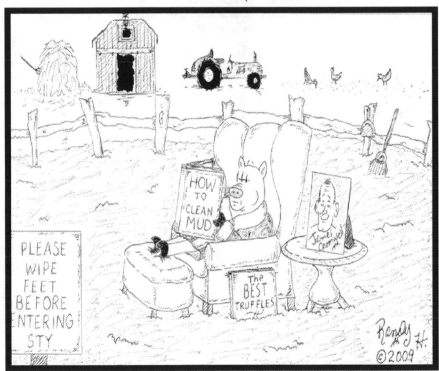

SCENE FROM "BABE: OBSESSIVE-COMPULSIVE PIG"

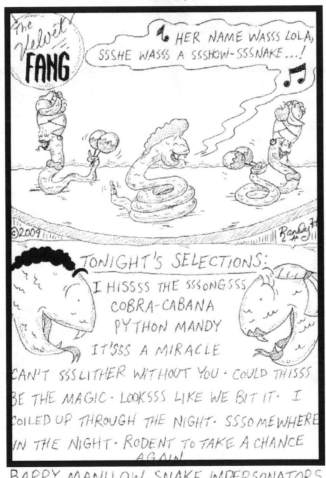

BARRY MANILOW SNAKE IMPERSONATORS

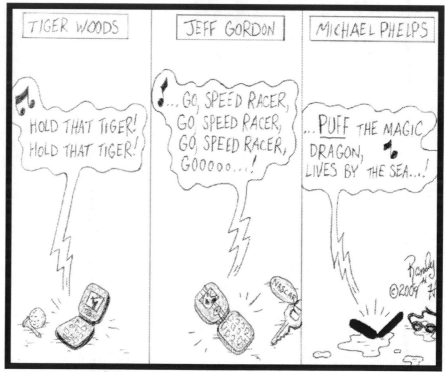

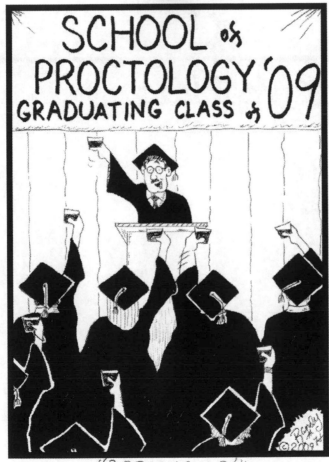

"BOTTOMS UP!"

82

Car Validation theatre

now playing:

"HOW GREEN WAS MY VALET"

coming soon:

"JURASSIC PARKING LOT" "VALET GIRL"

"VALET OF THE DOLLS" "BAREFOOT IN THE
 PARKING LOT"

"THE GLASS KEY" "BYE BYE BUICK"

©2009

VALET PARKING MOVIES

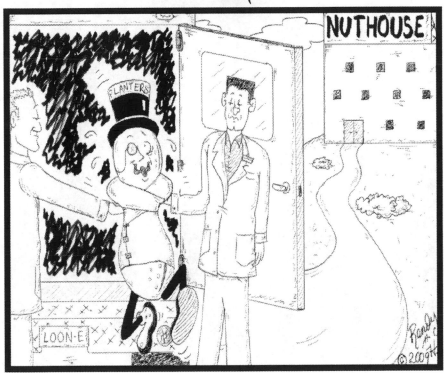

MR. PEANUT CRACKS HIS SHELL

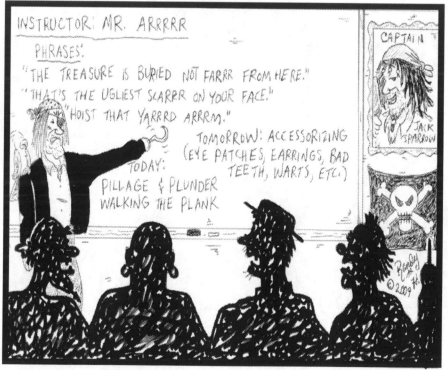

PIRATE SCHOOL

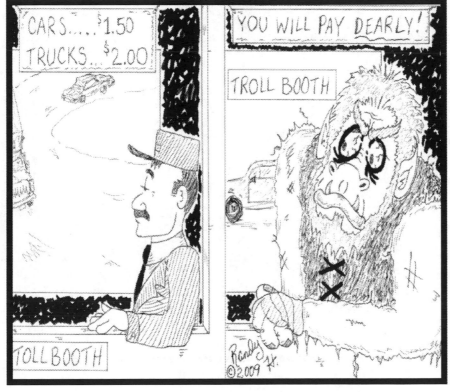

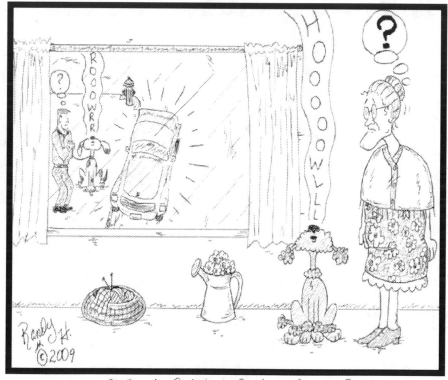

THE MARIAH CAREY CAR ALARM

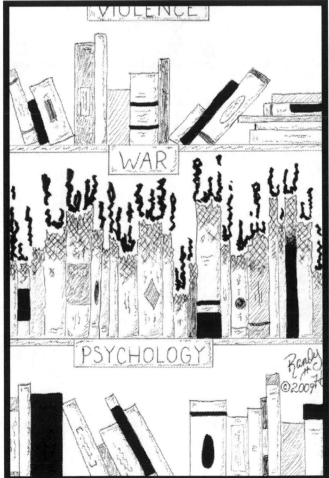

POLAR BEAR IN A BLIZZARD (SORRY, I WAS FEELING LAZY)

89

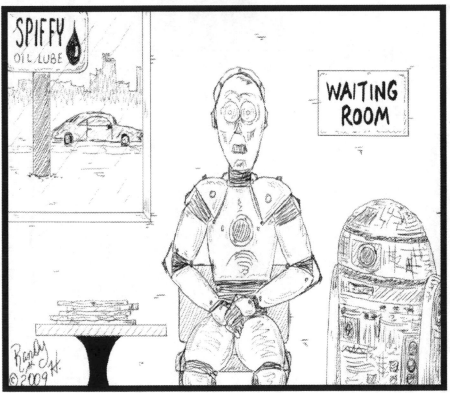

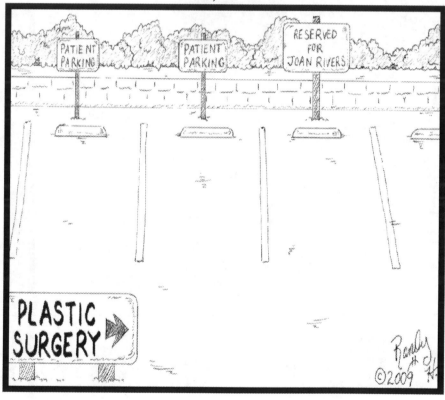

91

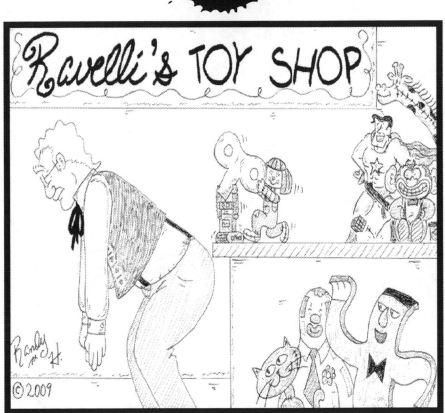

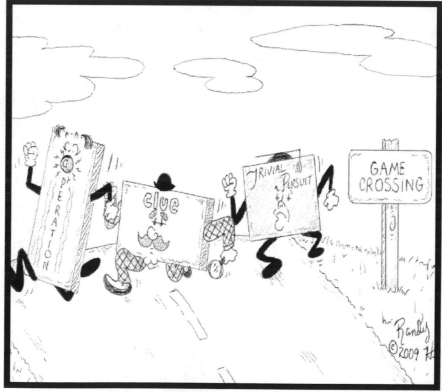

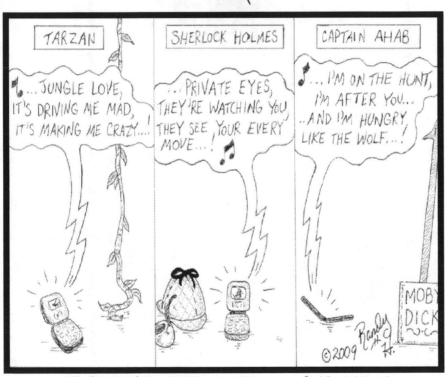

94

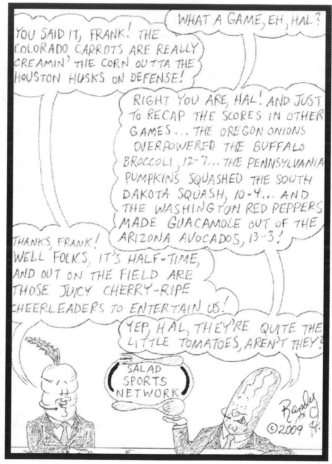

VEGGIE FOOTBALL GAMES

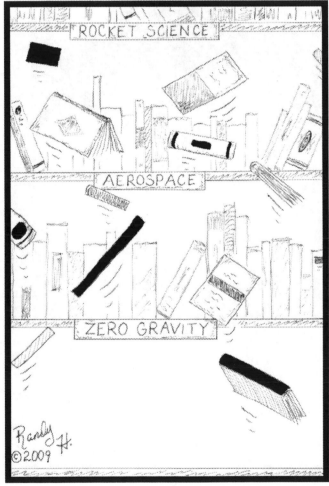

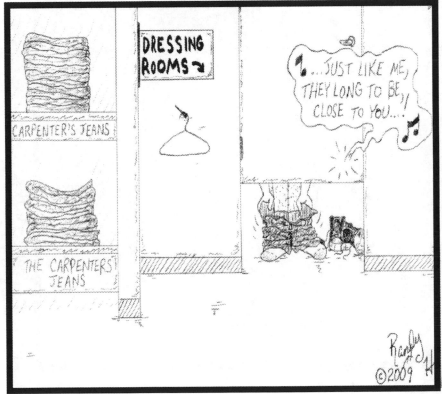

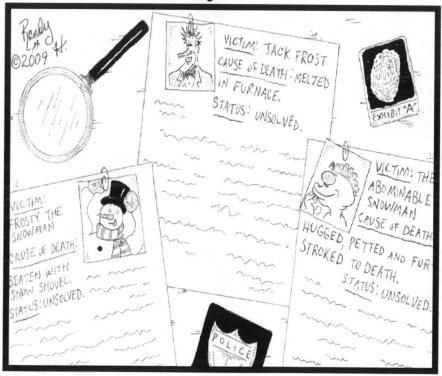

THE EXTREMELY COLD CASE FILES

99

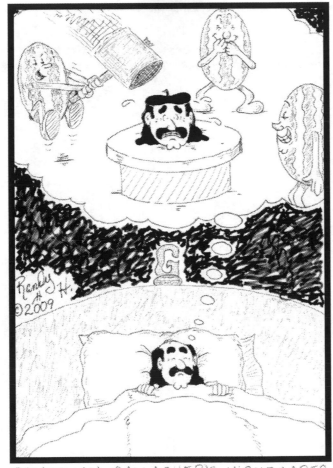

COMEDIAN GALLAGHER'S NIGHTMARES

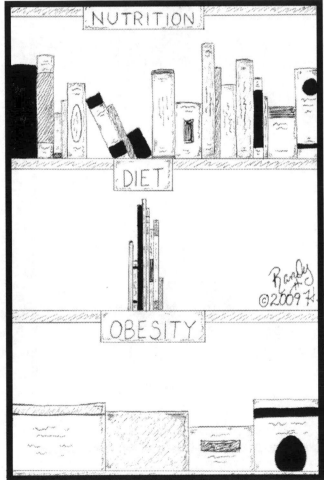

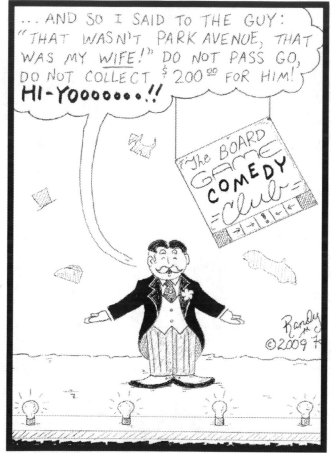

MONOPOLY MAN: STAND-UP COMIC

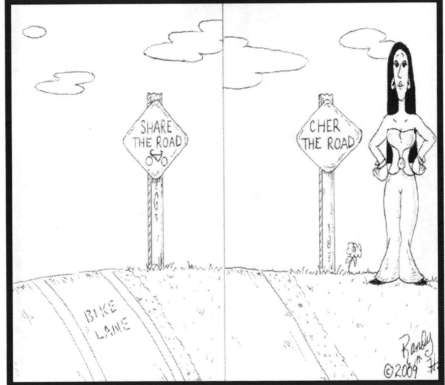

104

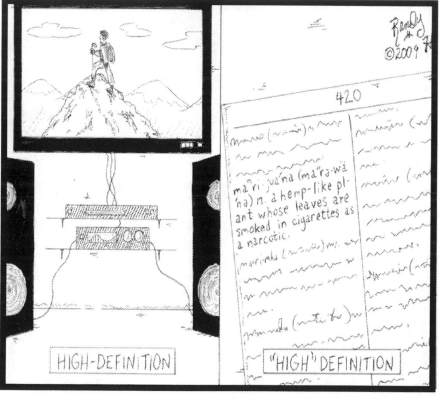

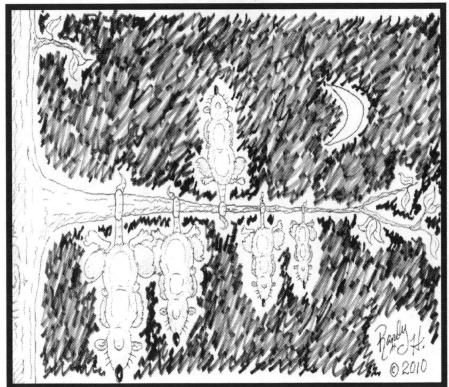

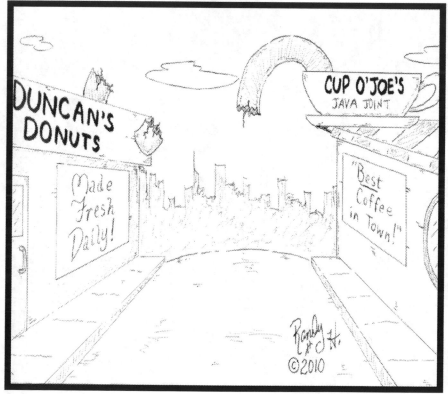

THE FRUIT-OF-THE-LOOM GANG HITS ROCK BOTTOM

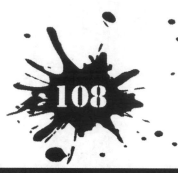

VIOLENT BROADWAY, PART 2

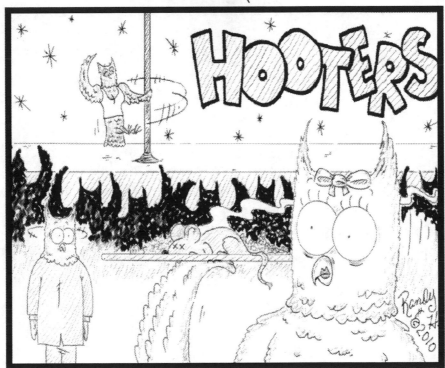

OWL CLUBS

110

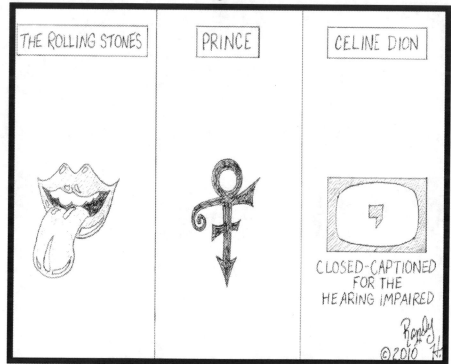

THE ROLLING STONES PRINCE CELINE DION

CLOSED-CAPTIONED
FOR THE
HEARING IMPAIRED

©2010

MUSIC ARTIST SYMBOLS

111

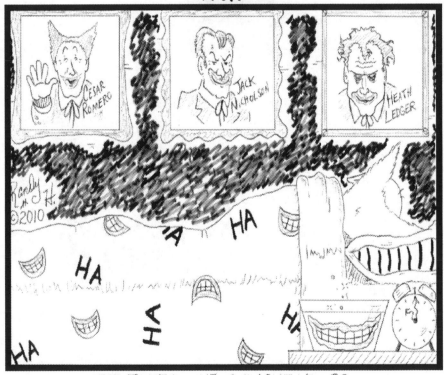

THE JOKER: THE TWILIGHT YEARS

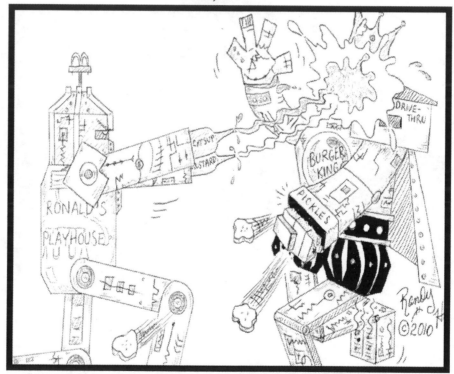

SCENE FROM "TRANSFORMERS: FAST FOOD WARS"

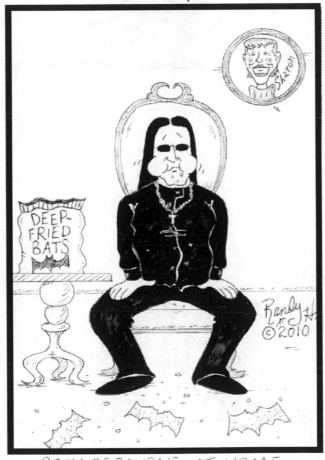

OZZY OSBOURNE AT HOME

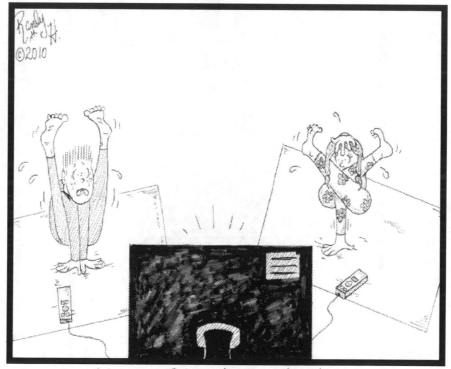

THE INTERACTIVE "Wii FIT:YOGA"

115

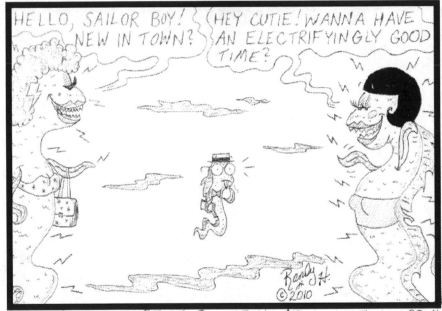

TAKING A DIFFERENT ROUTE HOME, LITTLE "ZAPPY"
POINDEXTER JUDGED FROM THE GARISH PAINTED
LADIES BEFORE HIM THAT HE HAD STUMBLED UPON A
"HOUSE OF EEL-REPUTE"...

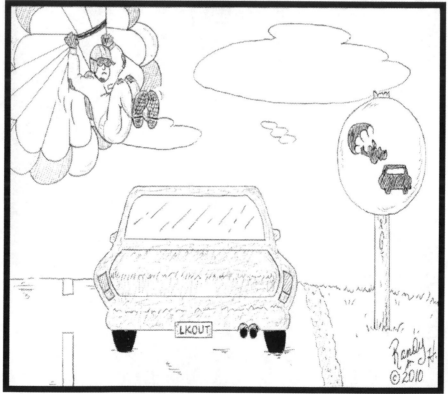

Honey D Comb theatre

now playing:
POLLEN NEWMAN
ROBBEE REDFORD
in
"THE STING"
coming soon:
"SHE WORE A YELLOW AND BLACK
RIBBON"
"THE STEPFORD HIVES"
"BUZZ TO THE FUTURE"
"FROM HIVE TO ETERNITY"
"ATTACK OF THE FIFTY-FOOT WASP"
"YOUNG FRANKENSTING"
"THE COLOR OF HONEY"
"THE HIVE AND THE MIGHTY"

Bagley H.
©2010

BEE MOVIES

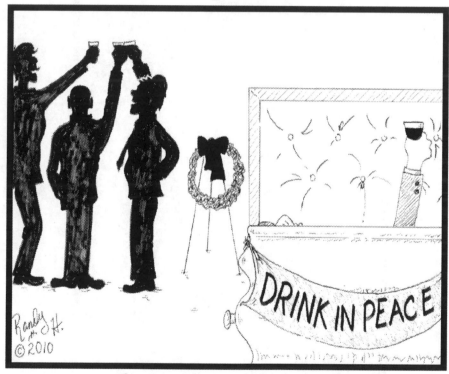

JACK DANIELS' FUNERAL

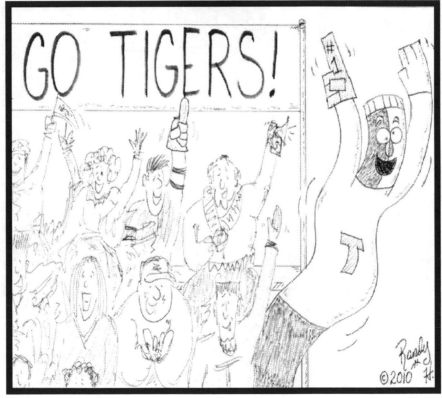

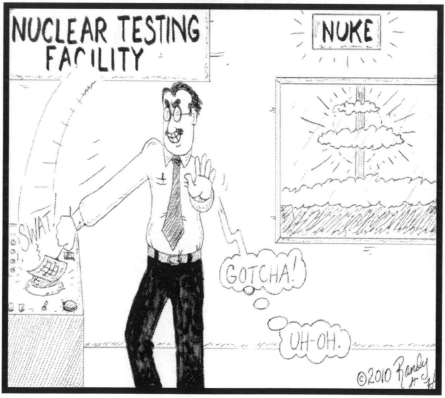

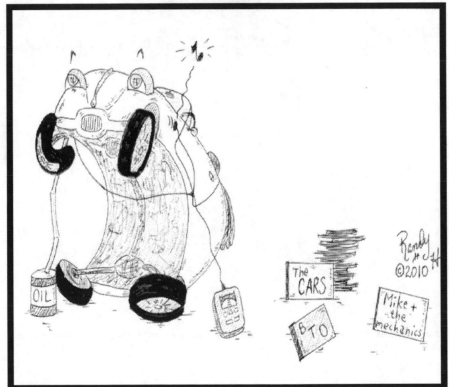

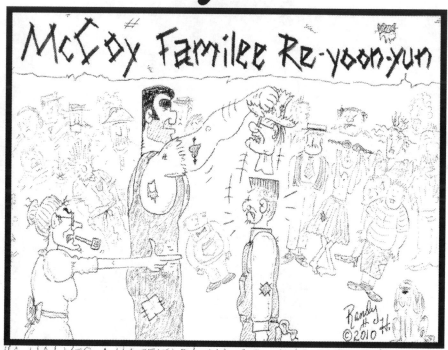

"A-HA! YER A HATFIELD! AH JUST KNEW YA T'WEREN'T NO REAL McCOY!!"

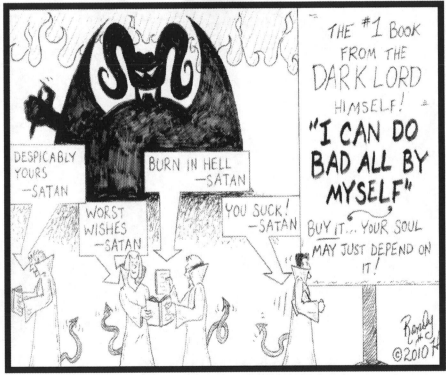

SATAN'S BOOK SIGNING SESSION

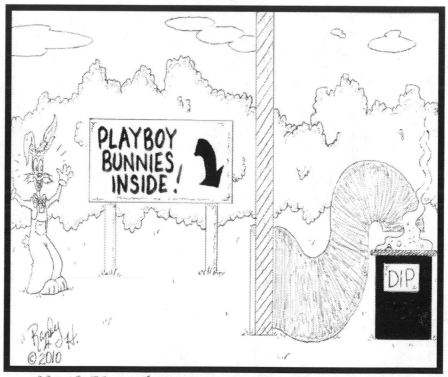

SCENE FROM "WHO FOOLED ROGER RABBIT?"

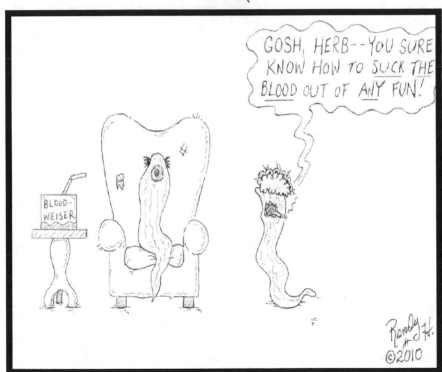

LEECH MARRIAGES

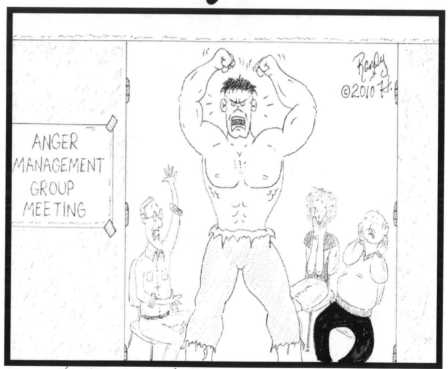

"HULK NO **WANT** TO SHARE FEELINGS!!"

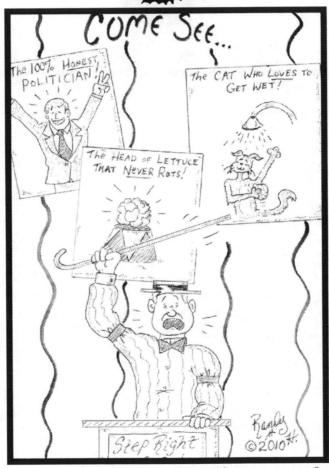

THE CARNIVAL OF CONTRADICTIONS

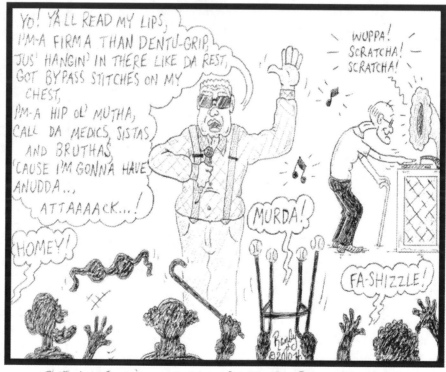

THE WORLD'S OLDEST RAPPER, BUSTA HERNIA

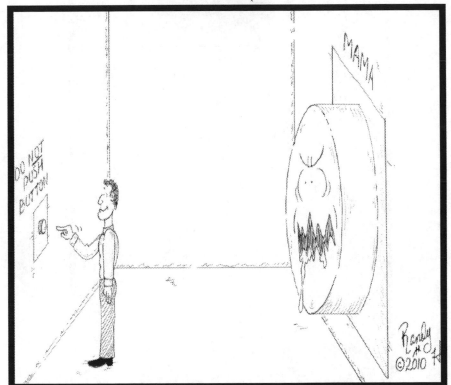

130

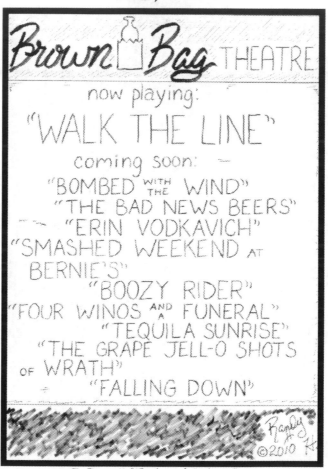

Brown Bag THEATRE

now playing:

"WALK THE LINE"

coming soon:

"BOMBED WITH THE WIND"

"THE BAD NEWS BEERS"

"ERIN VODKAVICH"

"SMASHED WEEKEND AT BERNIE'S"

"BOOZY RIDER"

"FOUR WINOS AND A FUNERAL"

"TEQUILA SUNRISE"

"THE GRAPE JELL-O SHOTS OF WRATH"

"FALLING DOWN"

Randy K
©2010

DRUNKEN MOVIES

131

132

THE SCI FI THRILLER "ATTACK OF THE FIFTY-FOOT TRANSVESTITE"

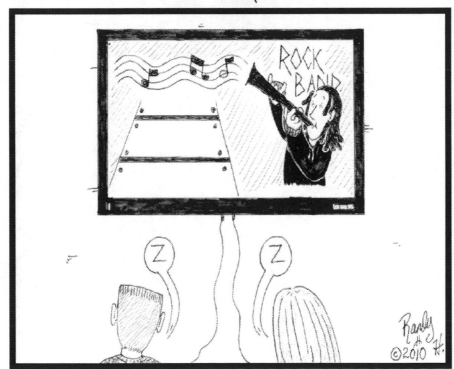

THE GAME "ROCK BAND: KENNY G EXPERIENCE"

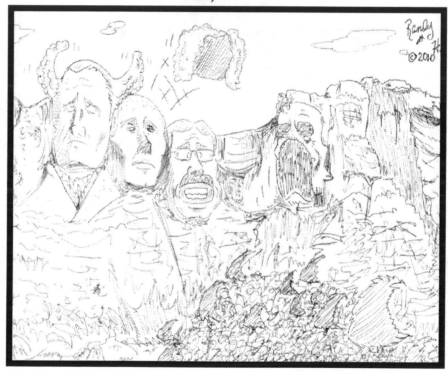

GUSTY WINDS AT MOUNT RUSHMORE

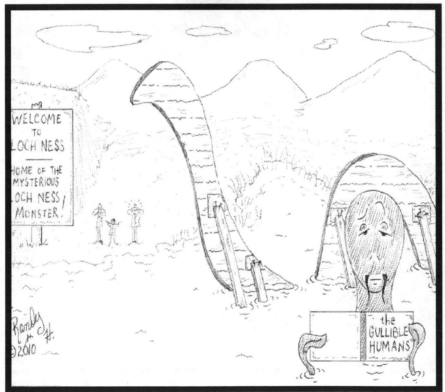

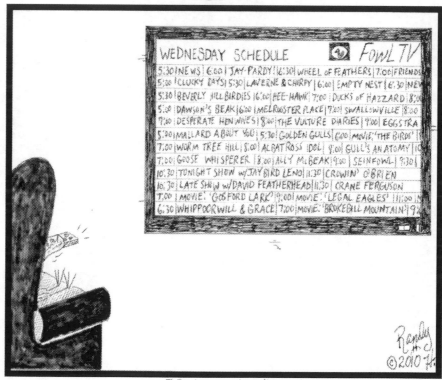

FOWL TELEVISION

SCENE FROM "STAR WARS: ATTACK OF THE CLOWNS"

PRIMITIVE GAME SHOWS

139

THE INTERACTIVE GAME "ROCK BAND: CULTURE CLUB"

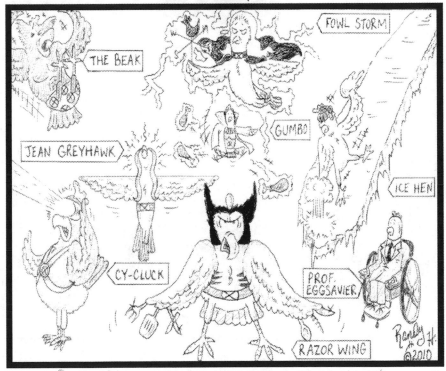

POULTRY MUTANT HEROES "THE X-HENS"

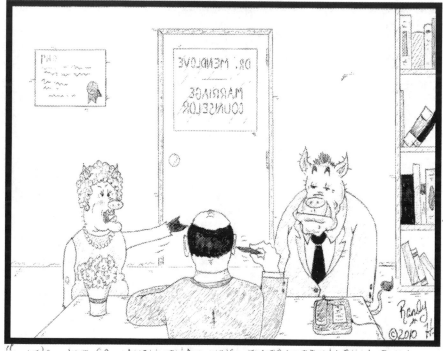

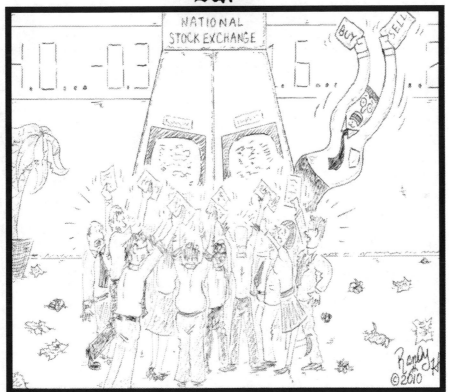

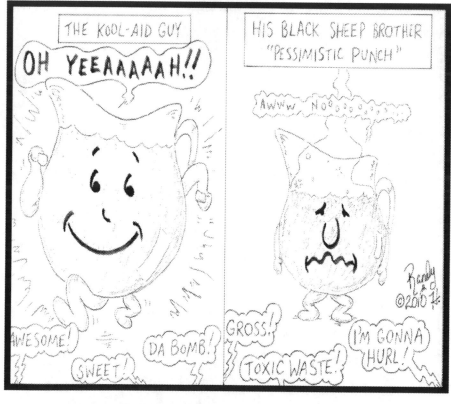

145

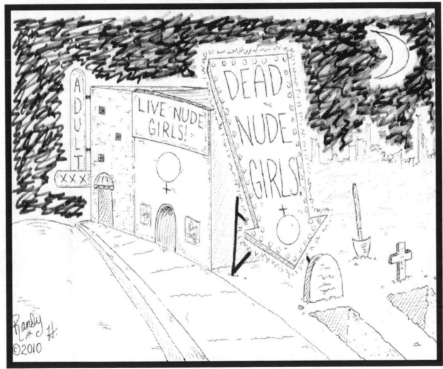

ZOMBIE PEEP SHOWS

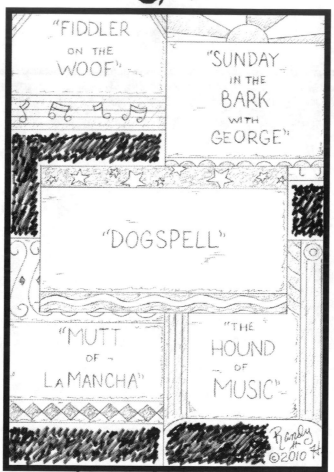

CANINE BROADWAY

147

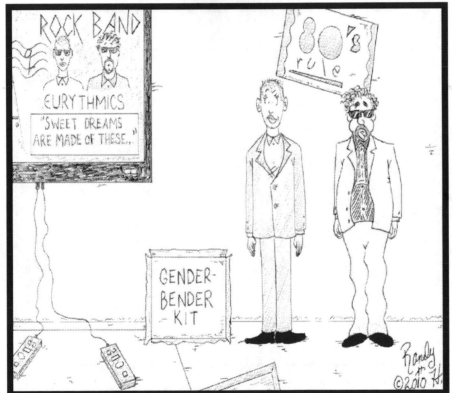

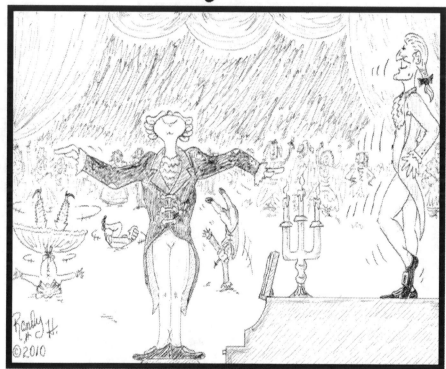

SCENE FROM "AMADEUS 2: ELECTRIC BOOGALOO"

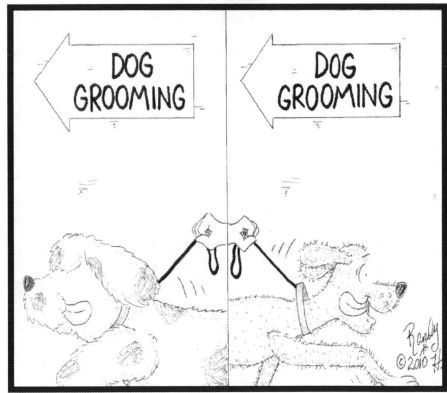

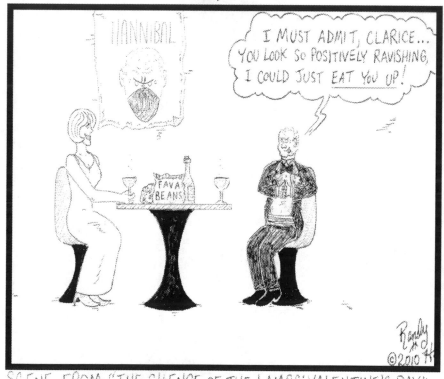

SCENE FROM "THE SILENCE OF THE LAMBS: VALENTINE'S DAY"

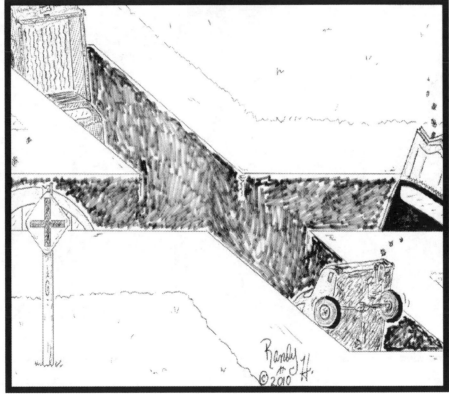

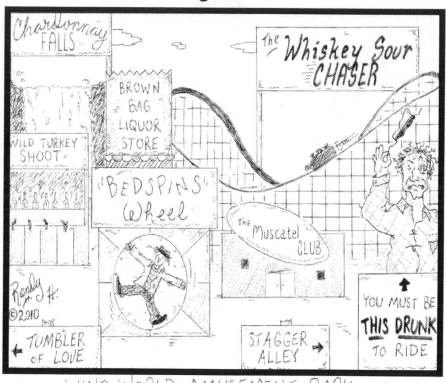

WINO WORLD AMUSEMENT PARK

THE SUPER-"FRIENDS"

155

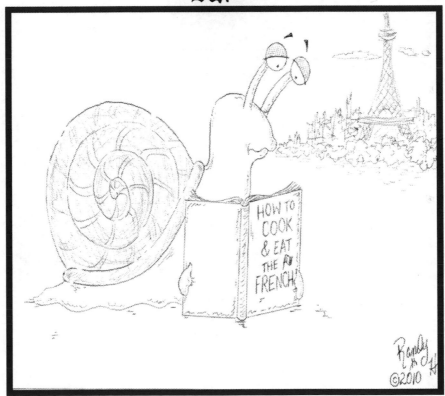

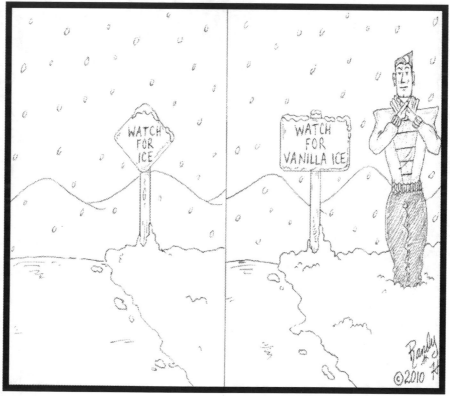

157

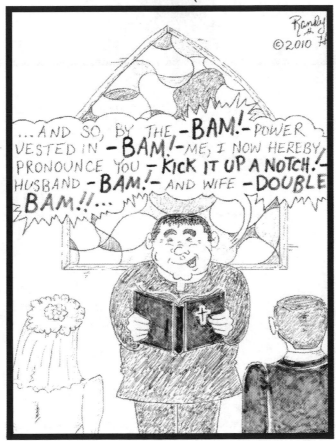

IF CHEF EMERIL LAGASSE WERE A MINISTER

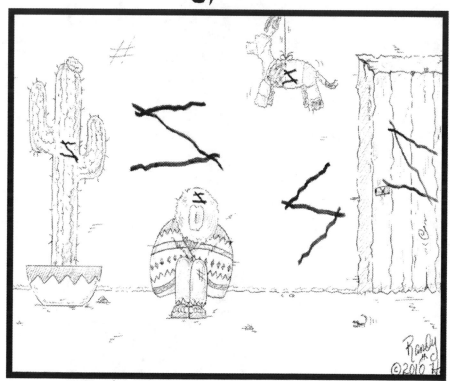

DYSLEXIC ZORRO STRIKES AGAIN

159

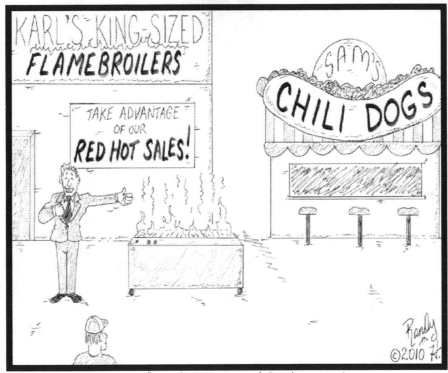

AN EXPLOSIVE COMBINATION

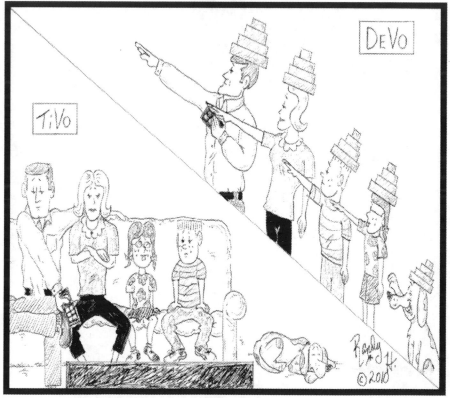

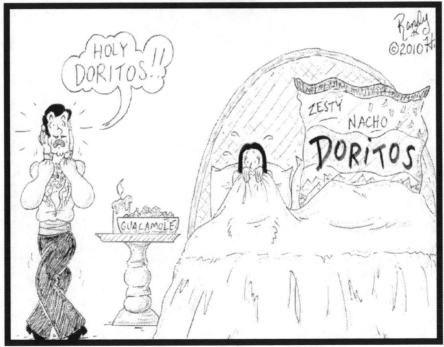

THE SPANISH SOAP OPERA "PARA EL AMOR DE NACHOS"
("FOR THE LOVE OF NACHOS")

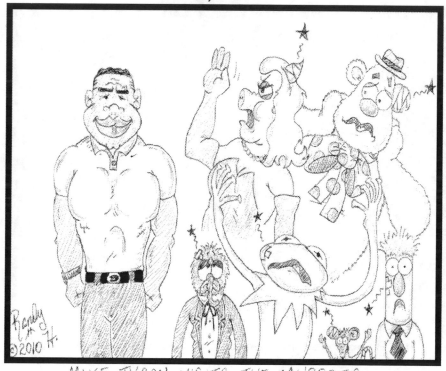

MIKE TYSON VISITS THE MUPPETS

163

"TWILIGHT FEVER" HITS NOAH'S ARK

THE GINGERBREAD MAN GETS TATTOOED

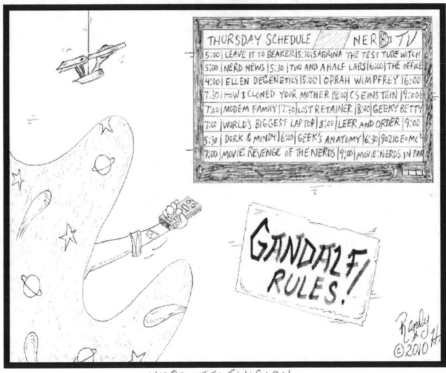

NERD TELEVISION

166

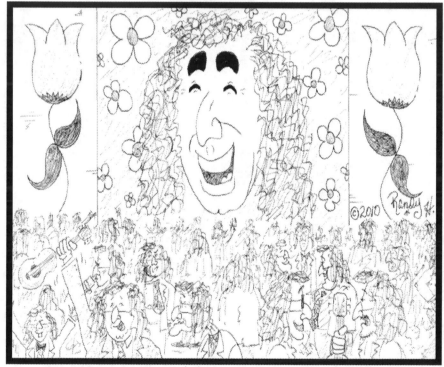

AT THE TINY TIM CONVENTION

167

GAME BOARD NEWS

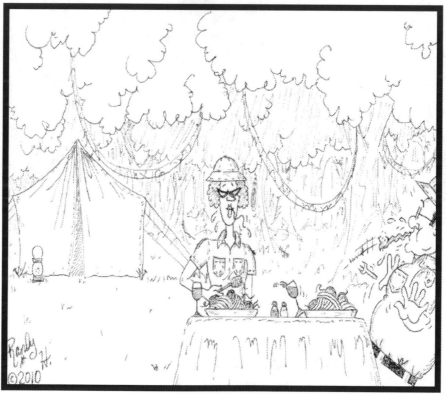

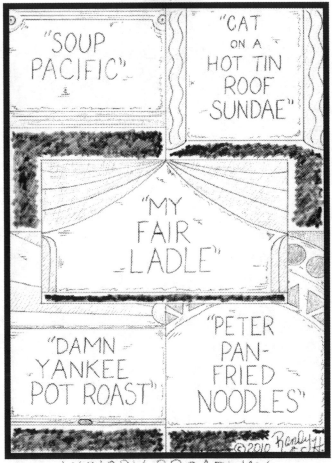

HUNGRY BROADWAY

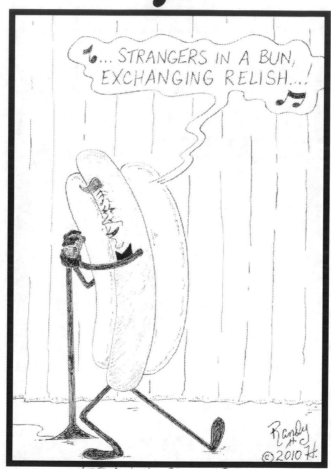

"FRANK" SINATRA

ABOUT THE AUTHOR

Cartoonist Randy Halford was born and raised in Tracy, California. Currently residing in Idaho, he enjoys reading, writing, swimming, acting, singing, *Scooby-Doo* and classic comedies.

LOOK FOR THESE OTHER
LEFT FIELD TITLES...

The Cartoon Collection by RANDY HALFORD

More Cartoons by RANDY HALFORD

www.amazon.com